To Betsy —

Jeannette Montgomery Barron

July 2004

JEANNETTE MONTGOMERY BARRON
MIRRORS SPIEGEL

With a text by / Mit einem Text von Edmund White

Holzwarth Publications

For James

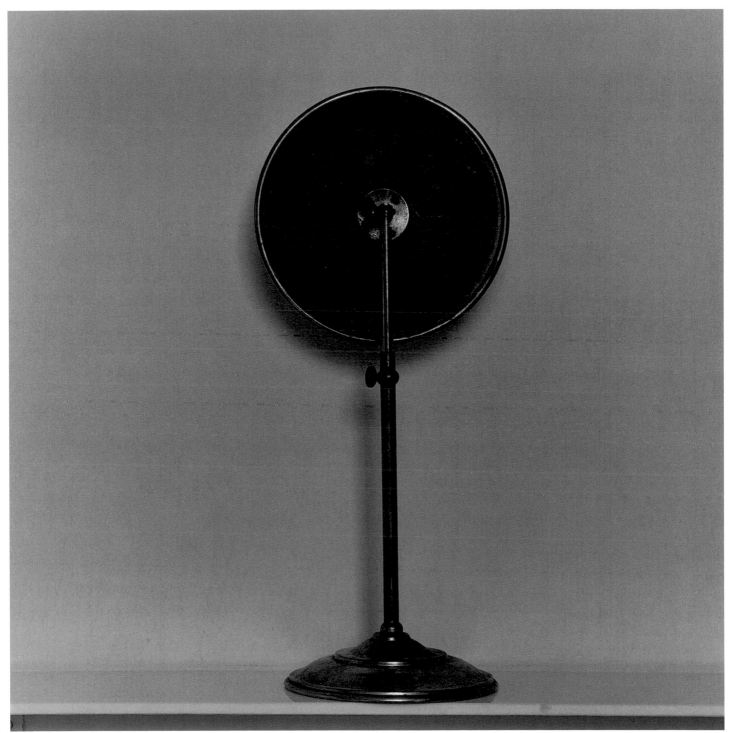

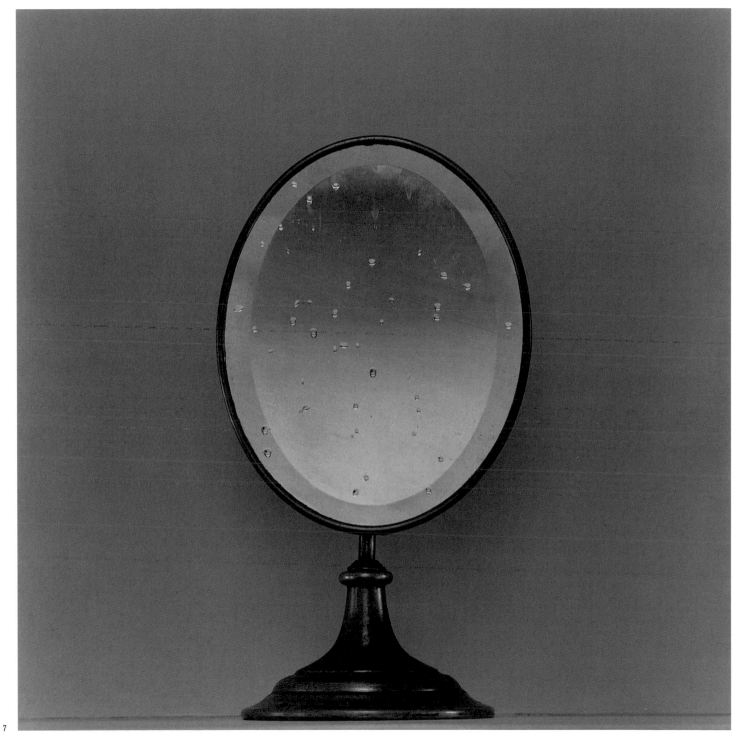

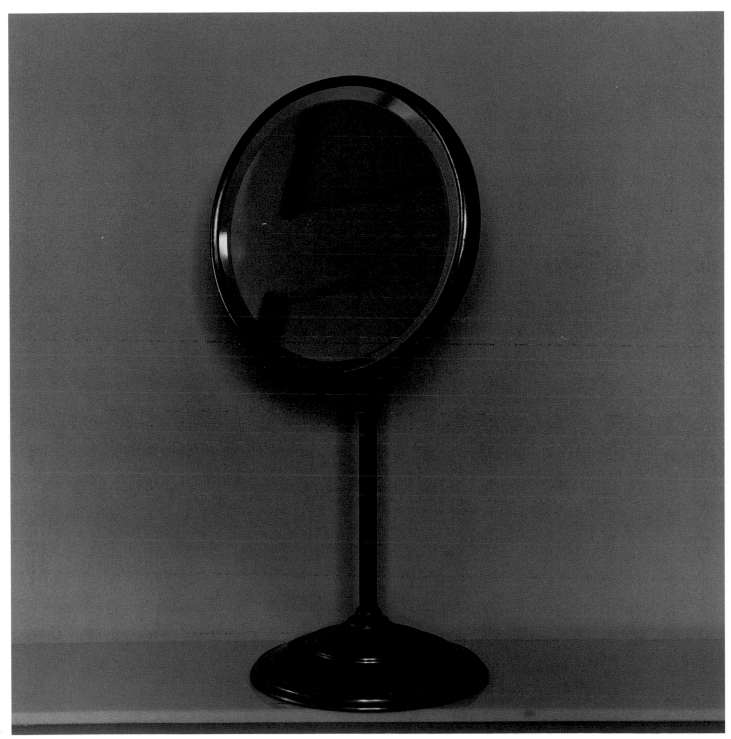

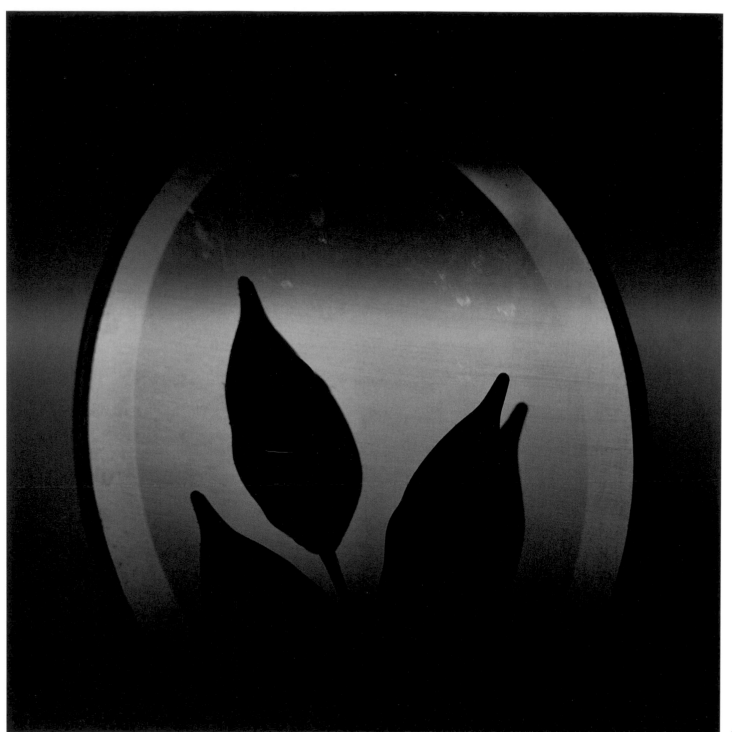

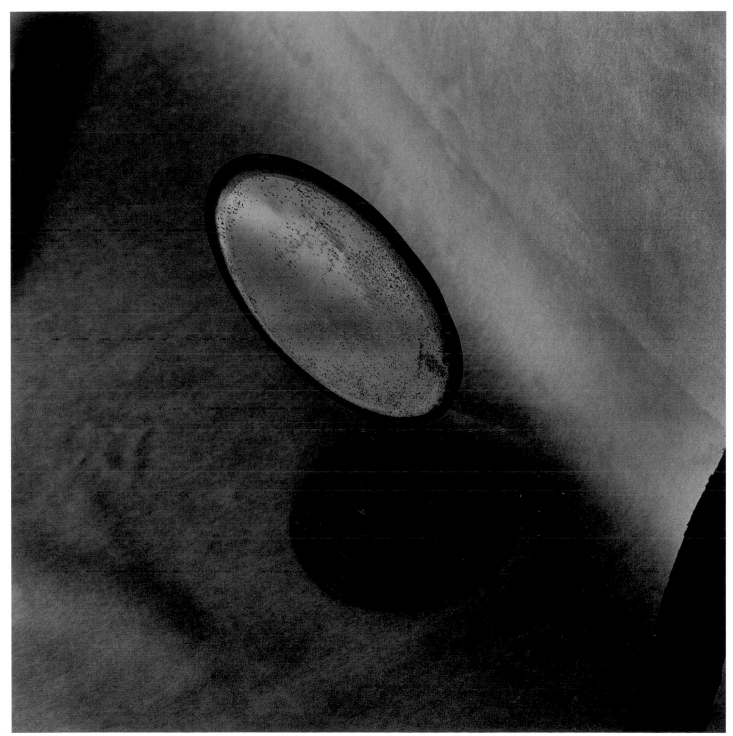

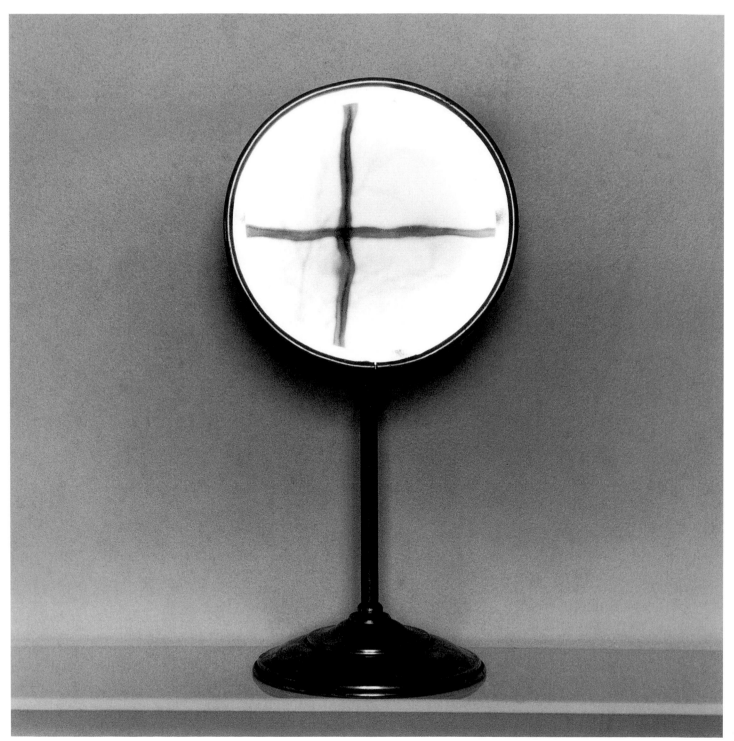

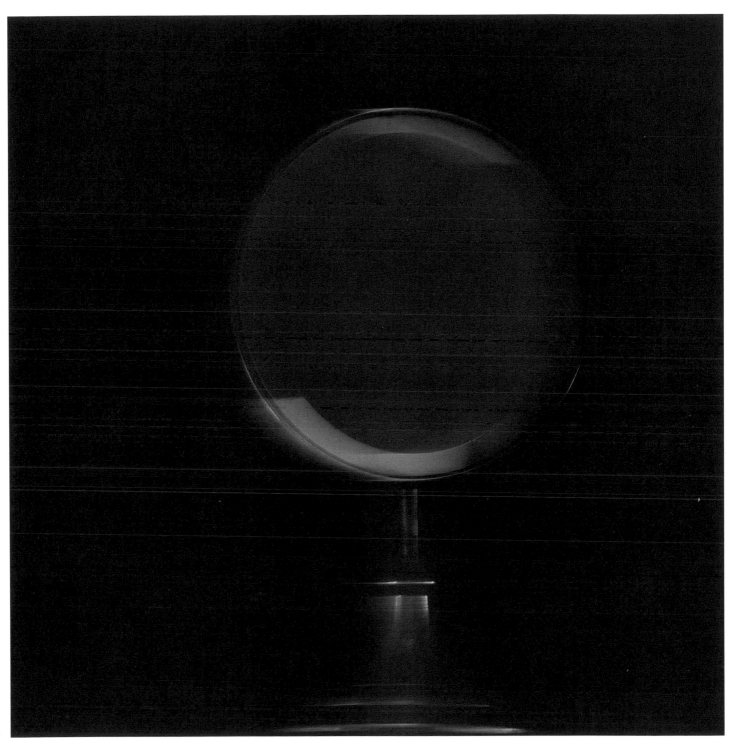

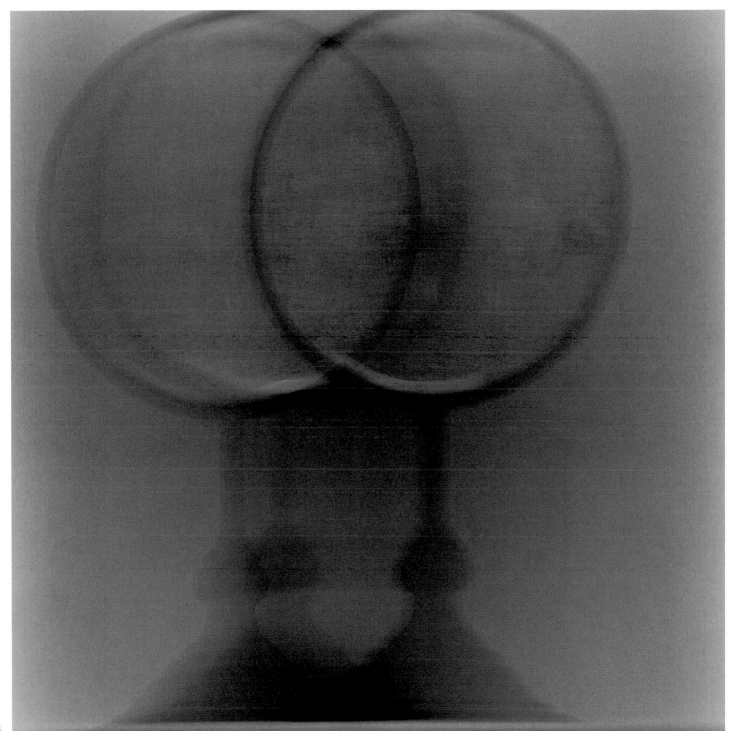

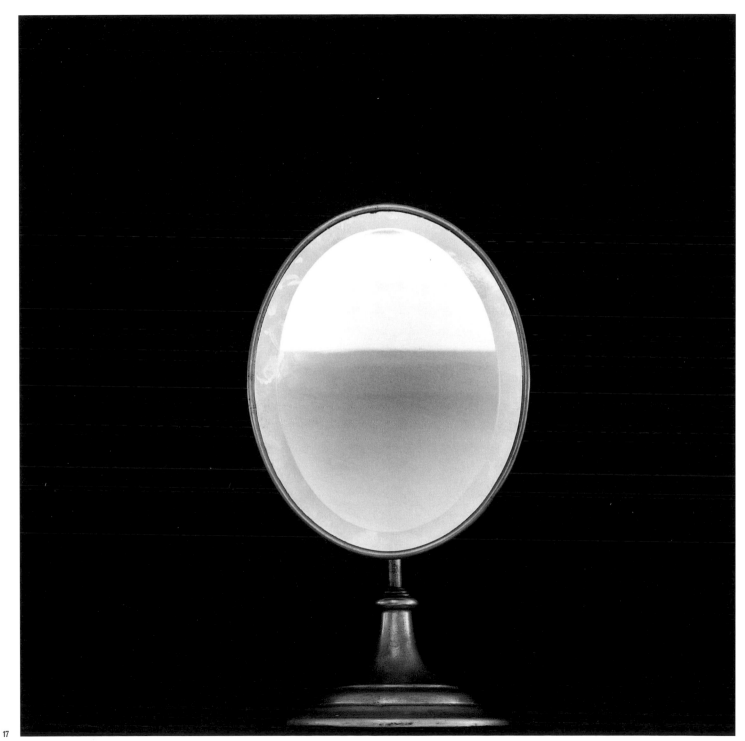

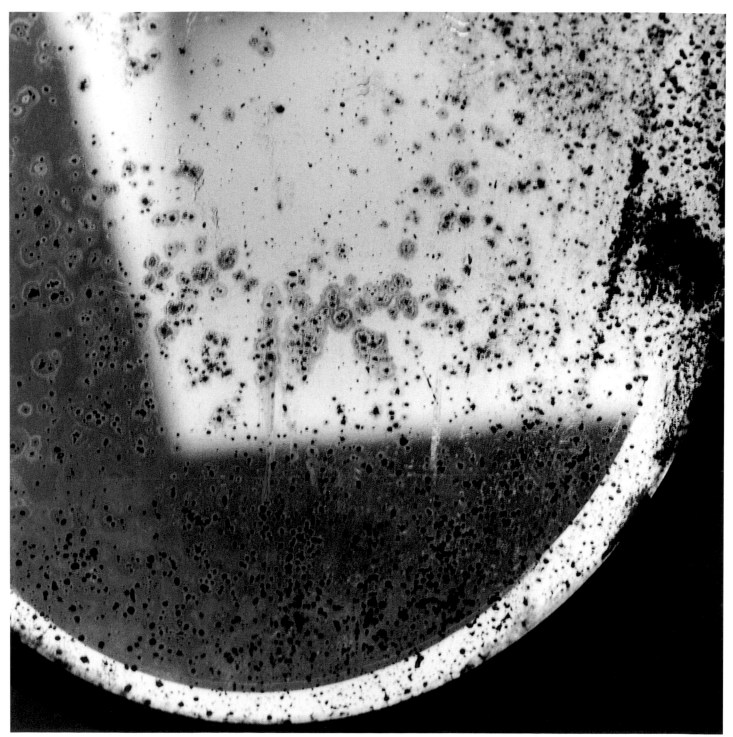

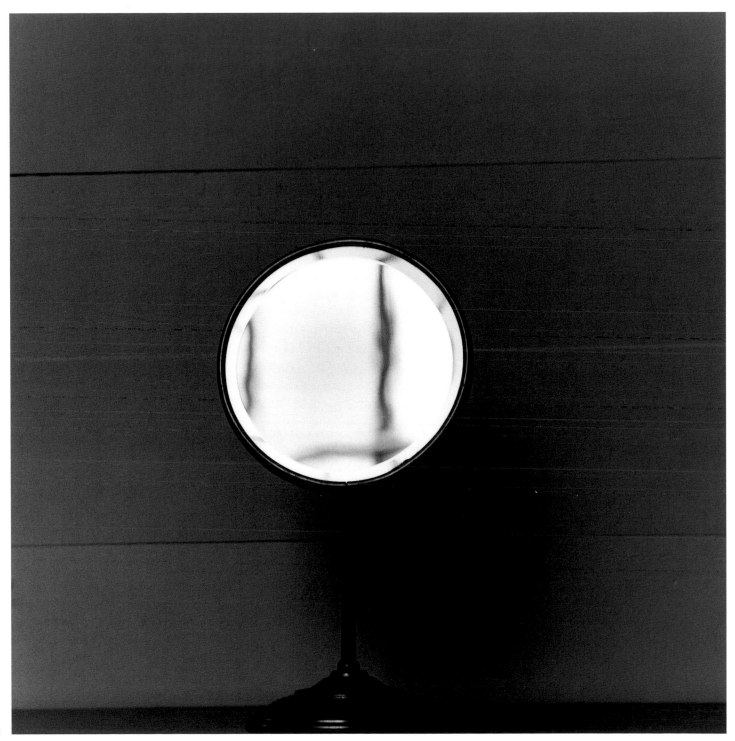

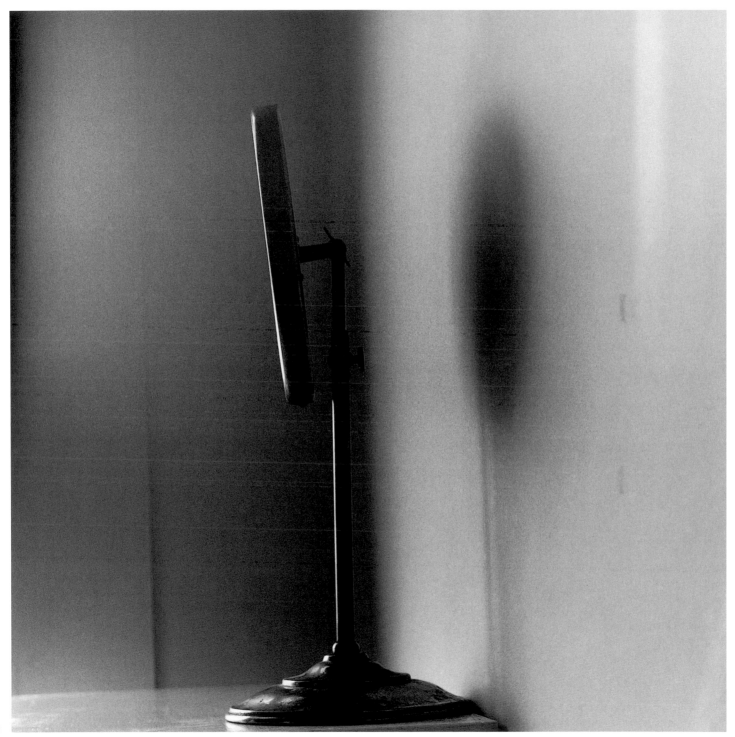

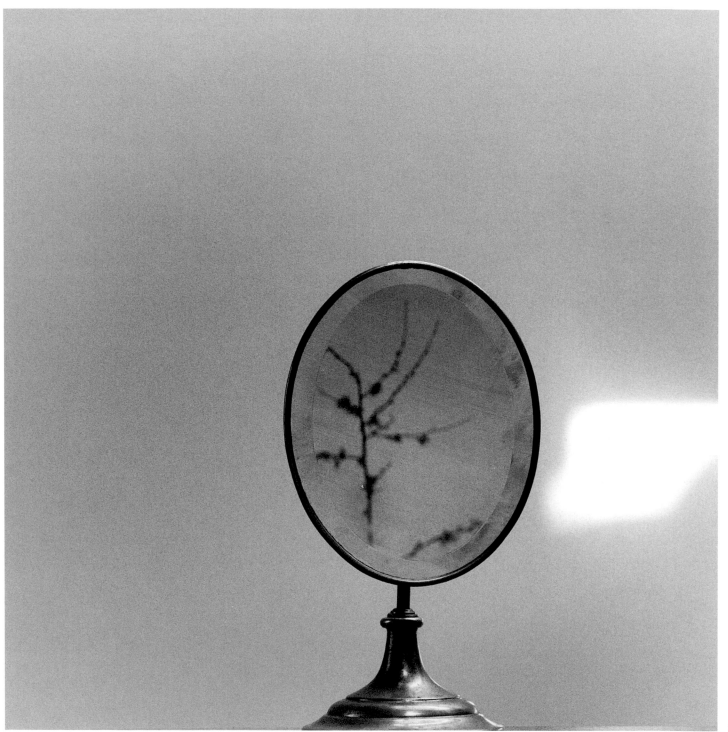

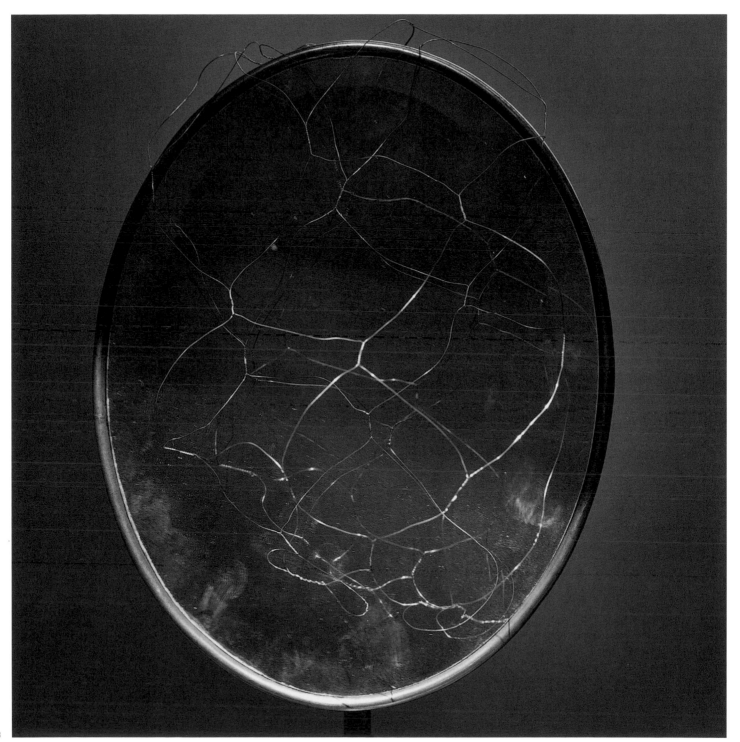

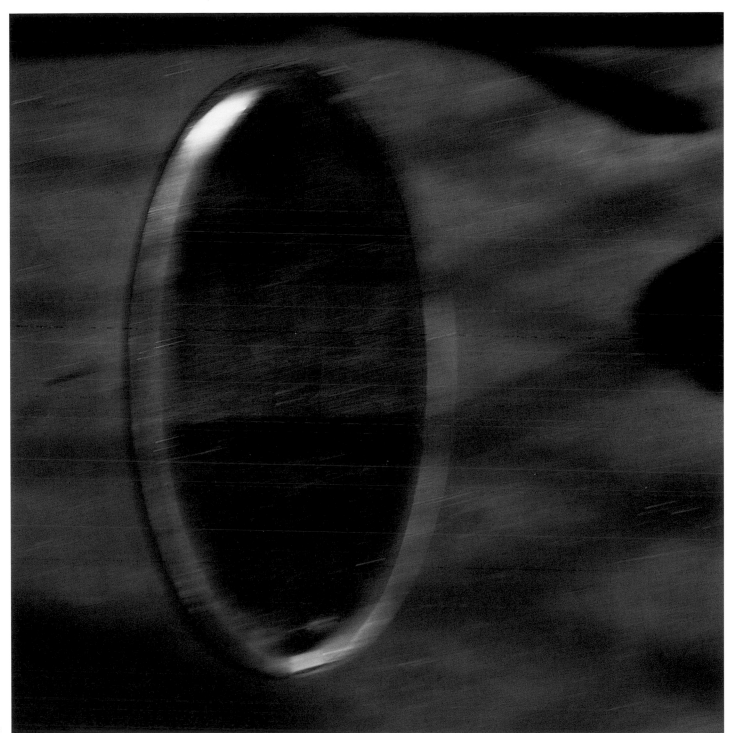

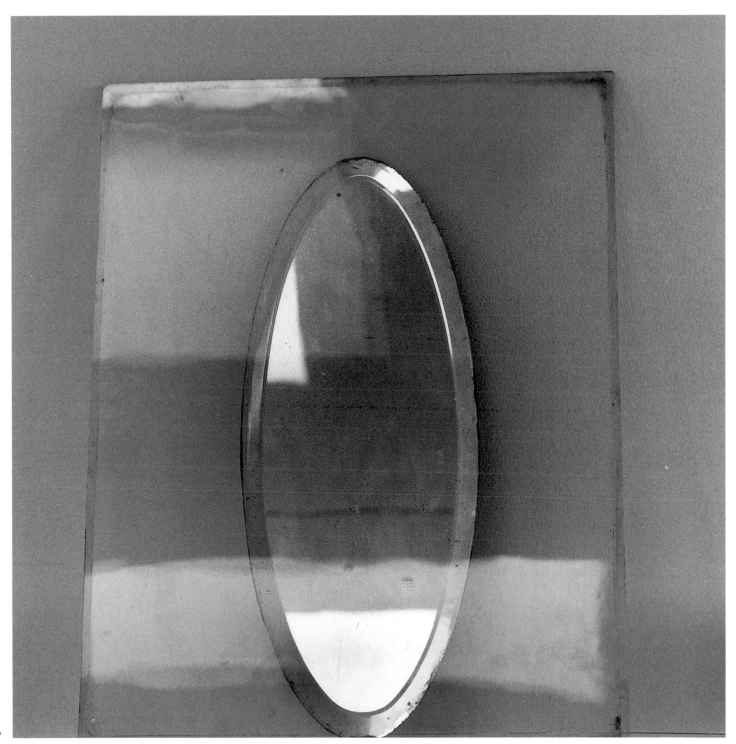

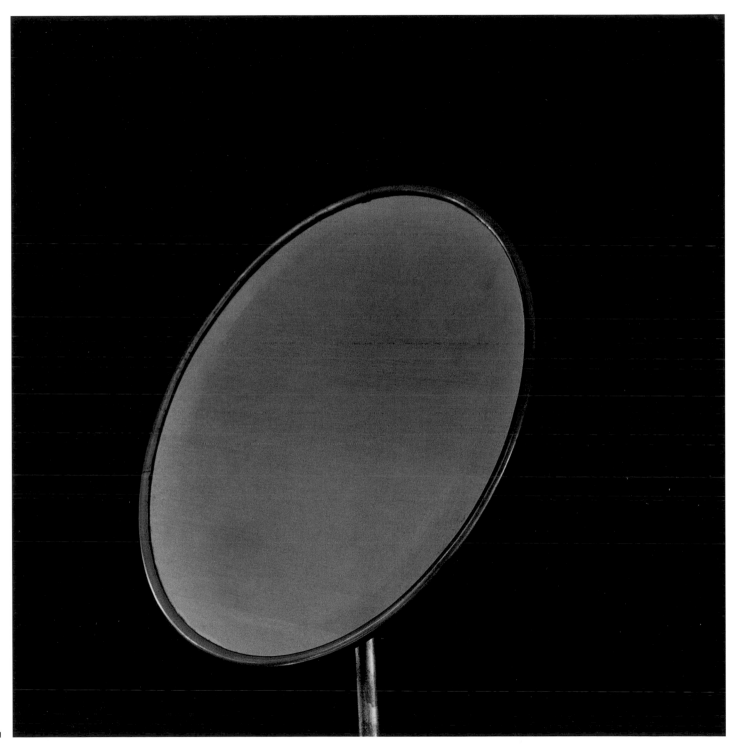

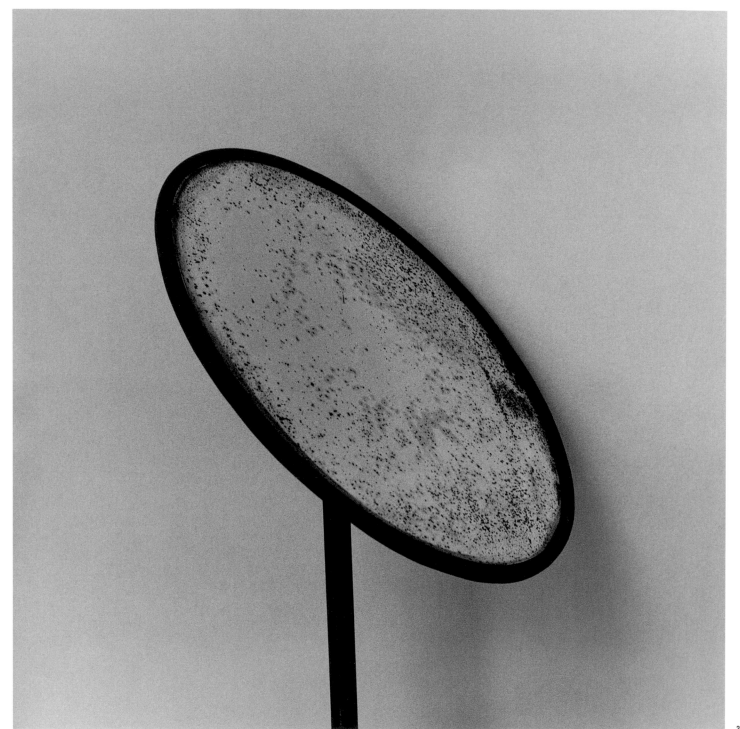

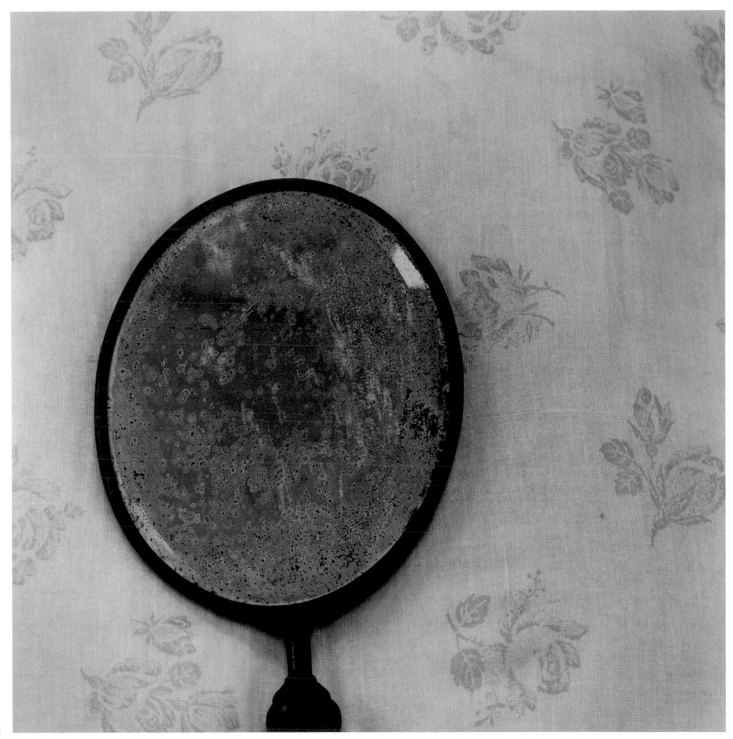

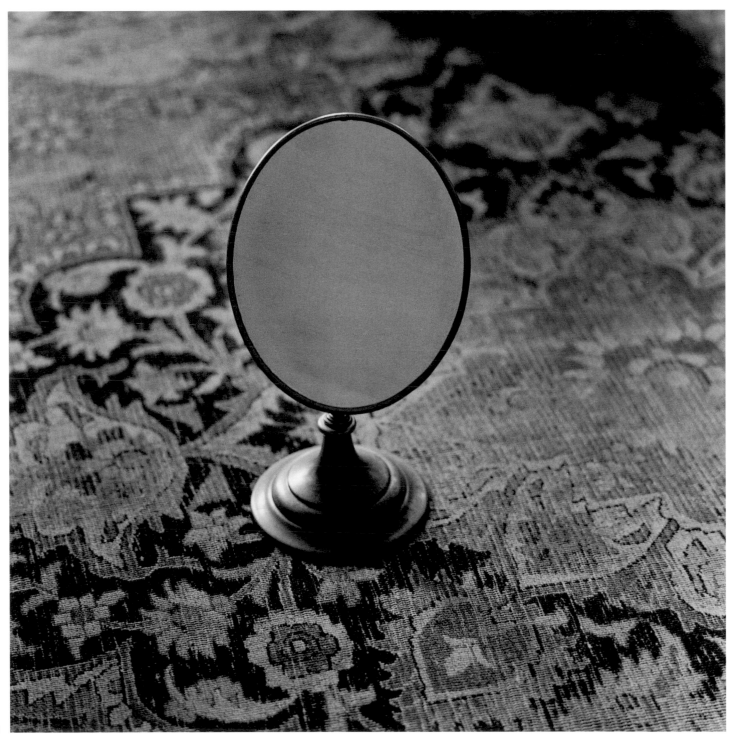

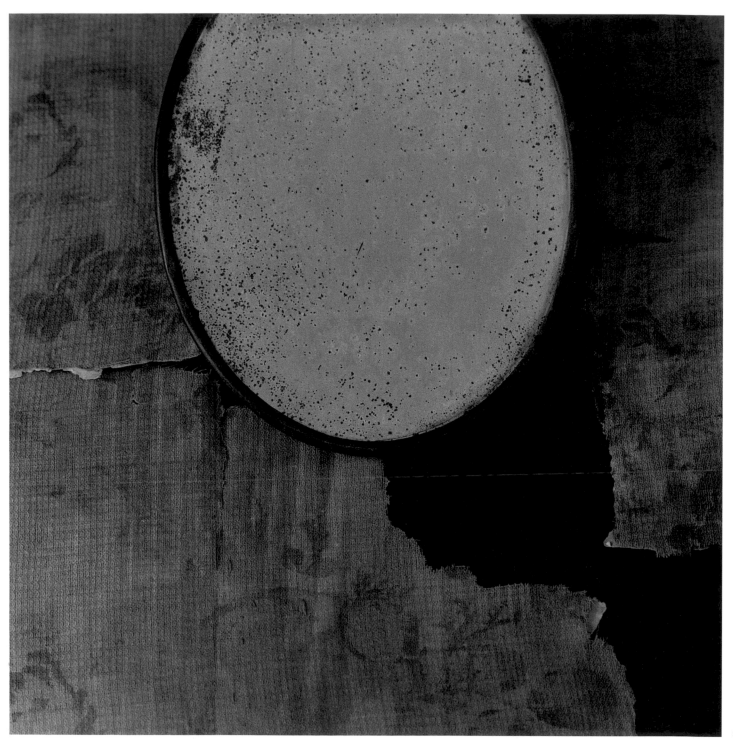

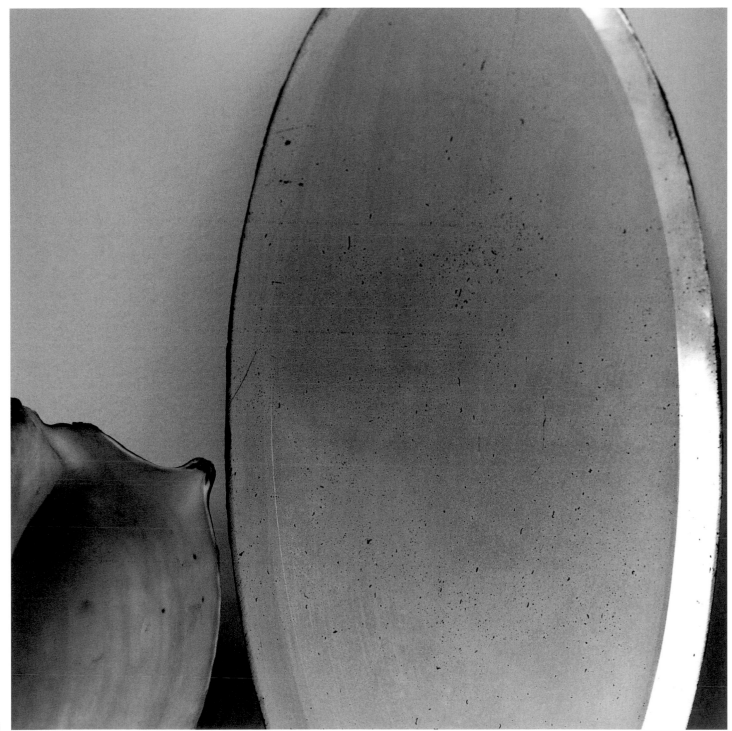

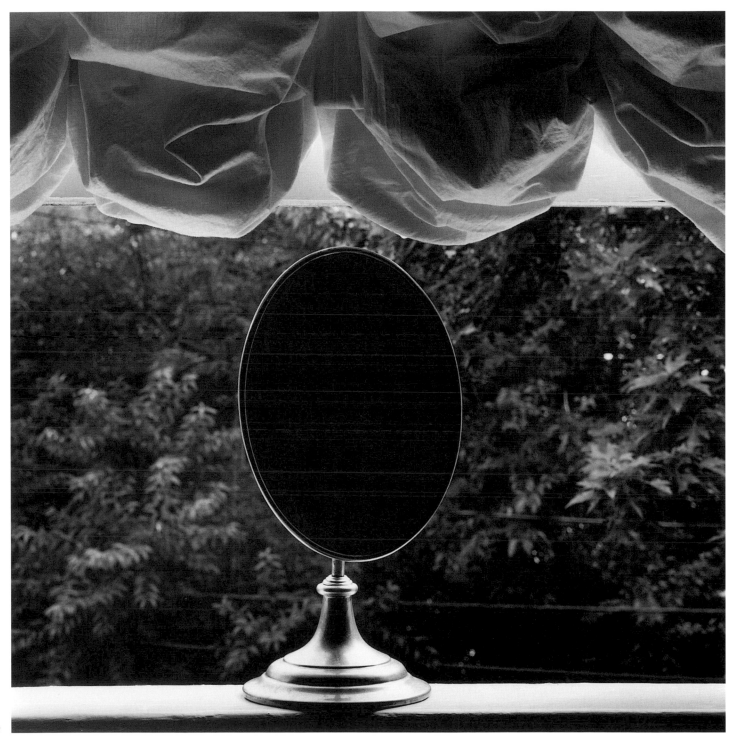

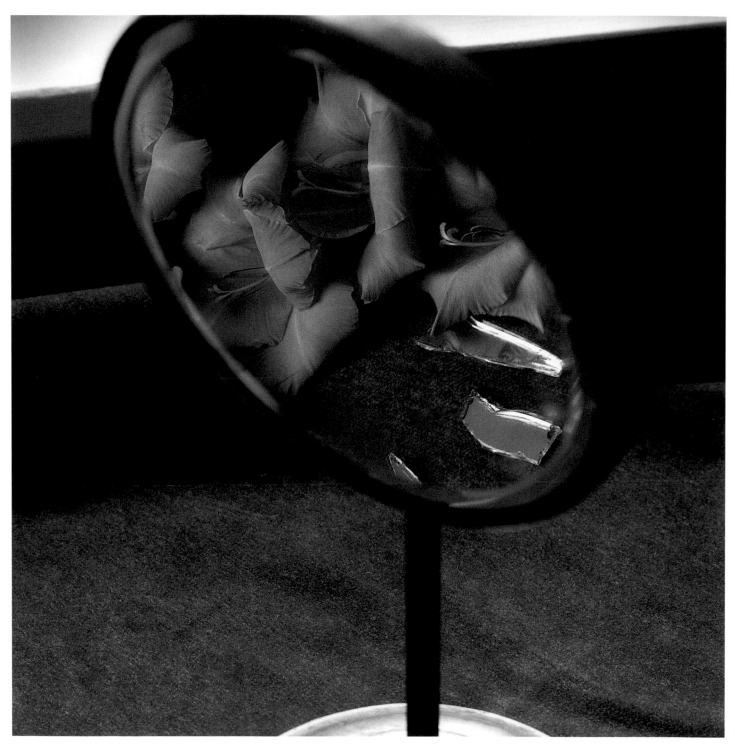

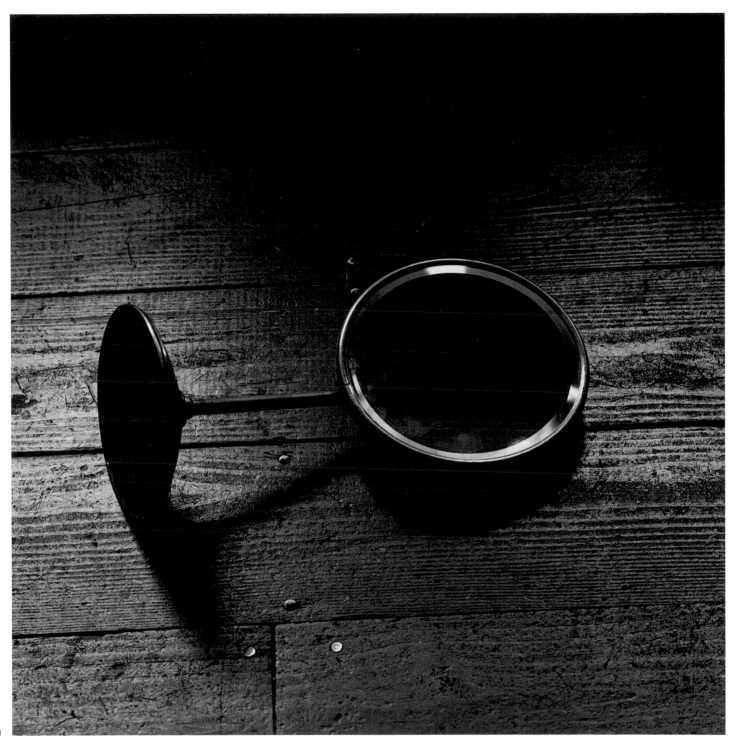

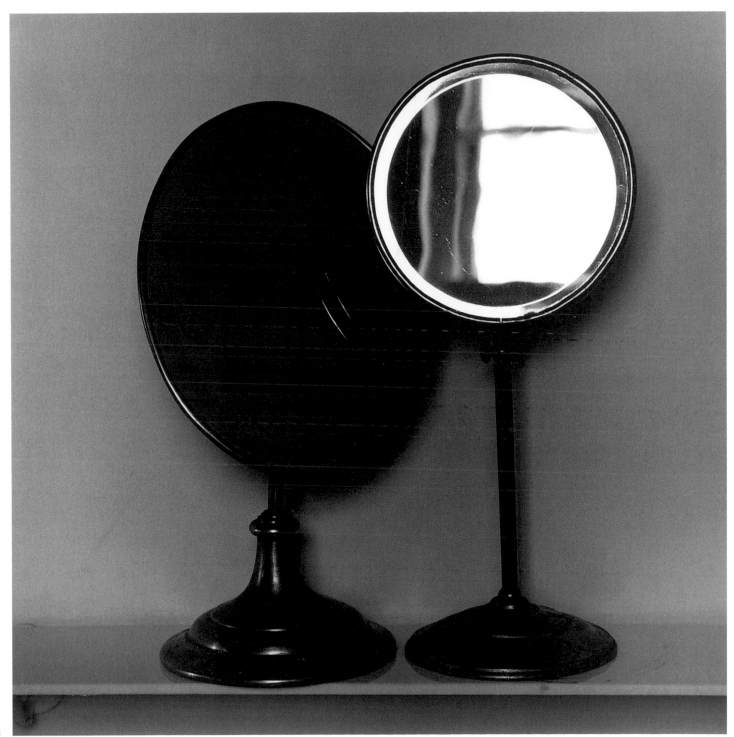

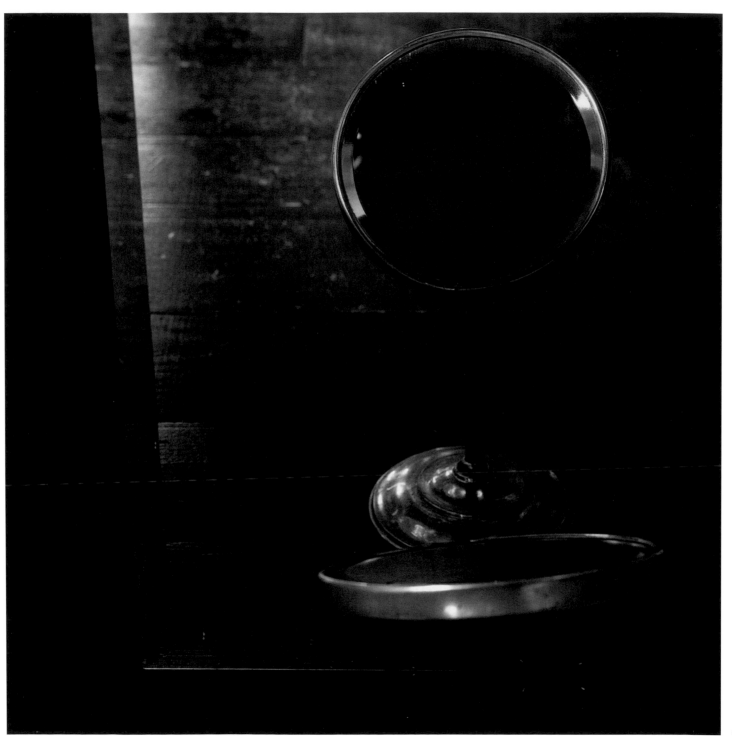

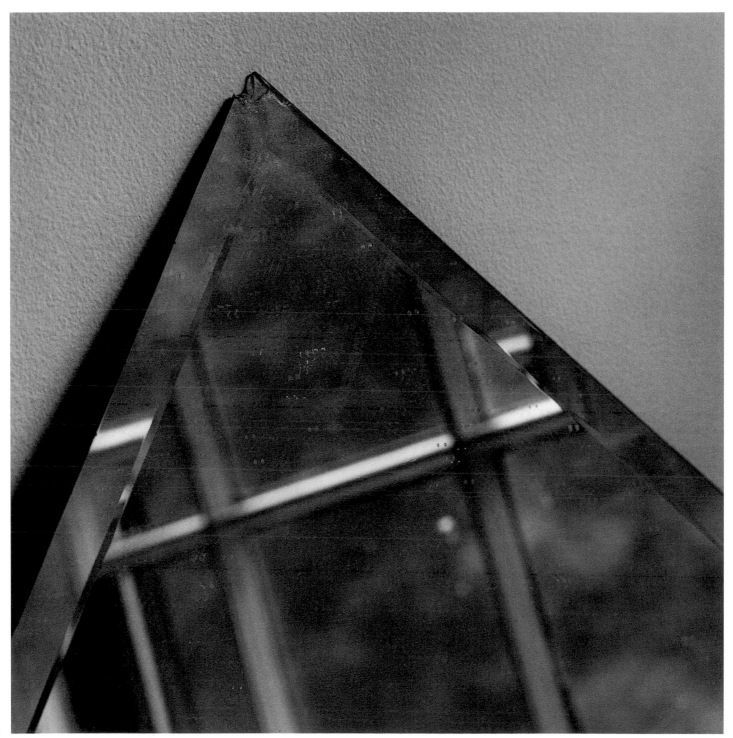

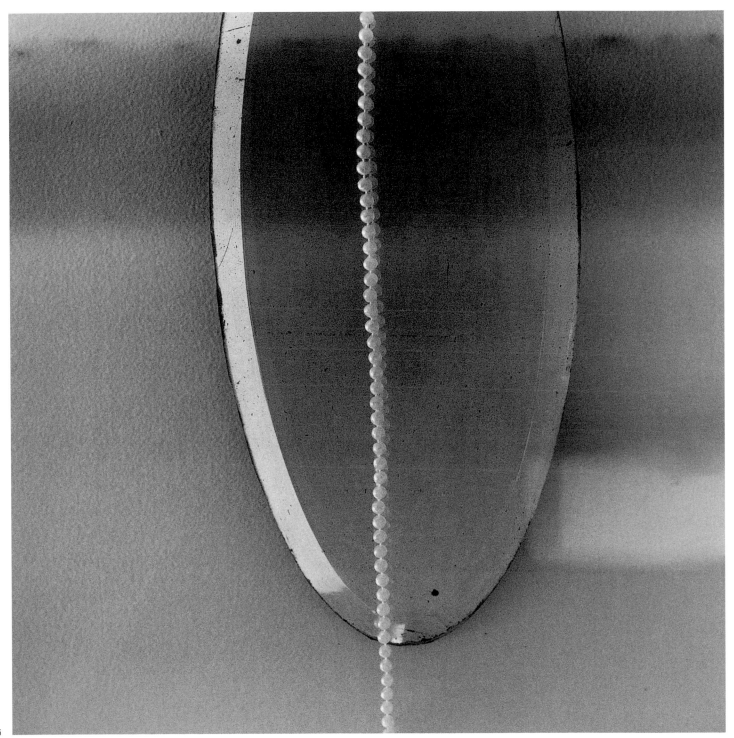

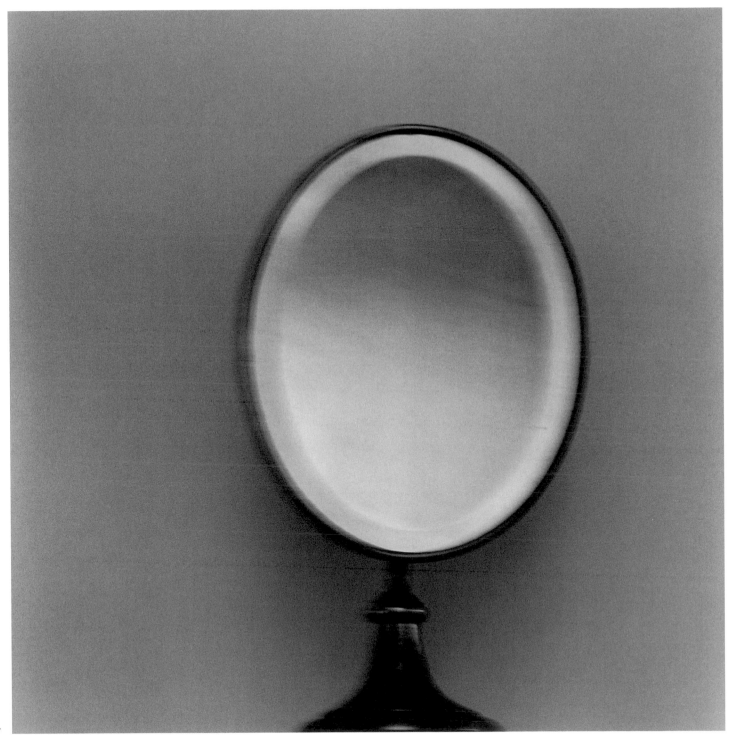

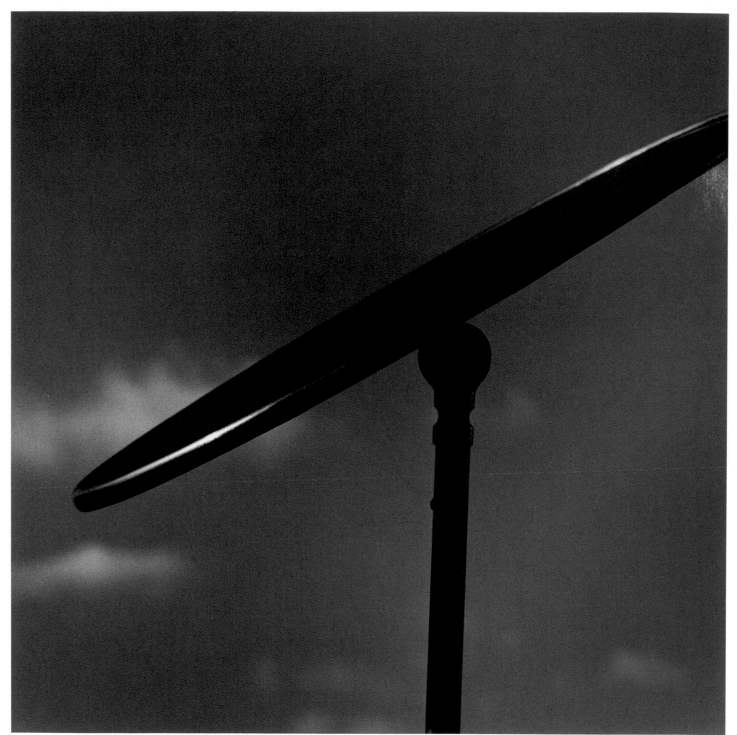

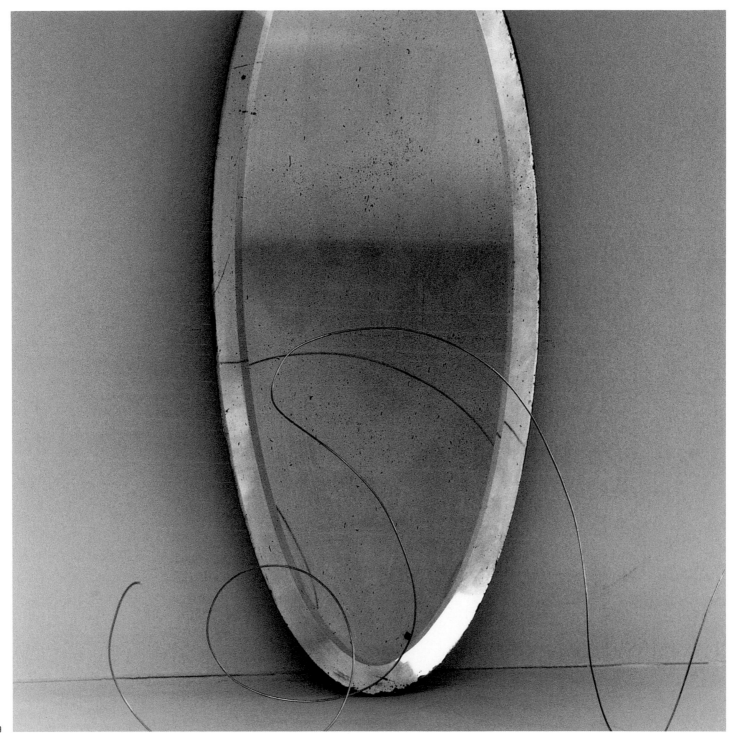

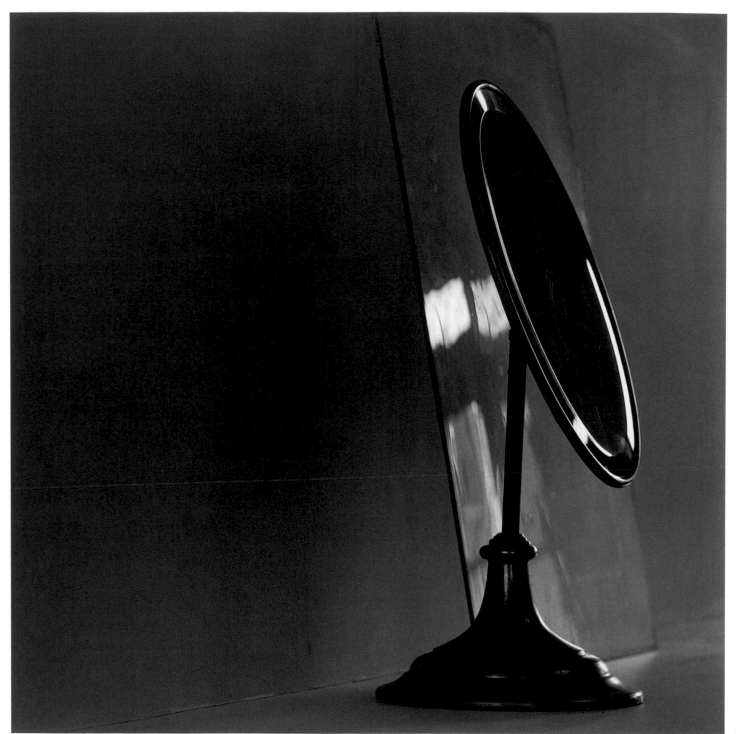

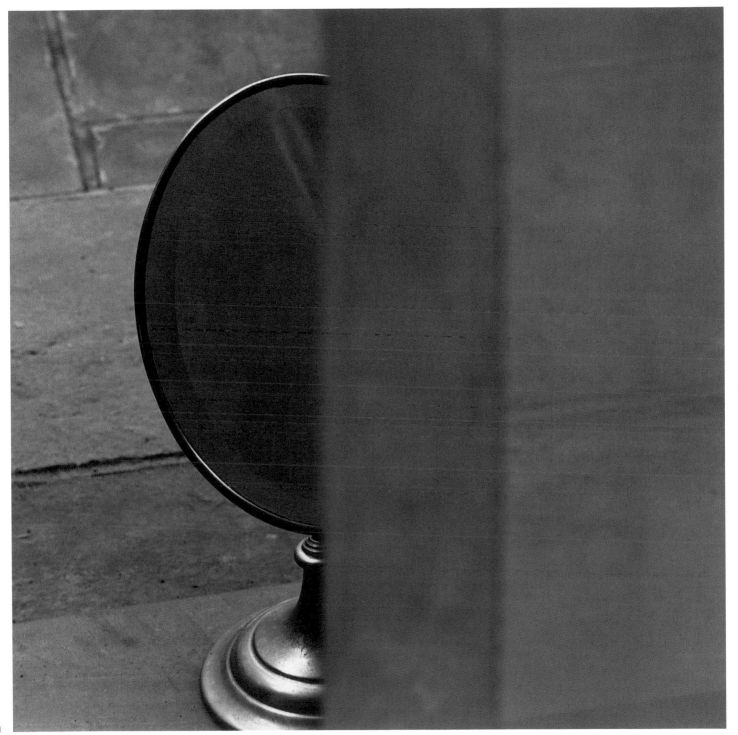

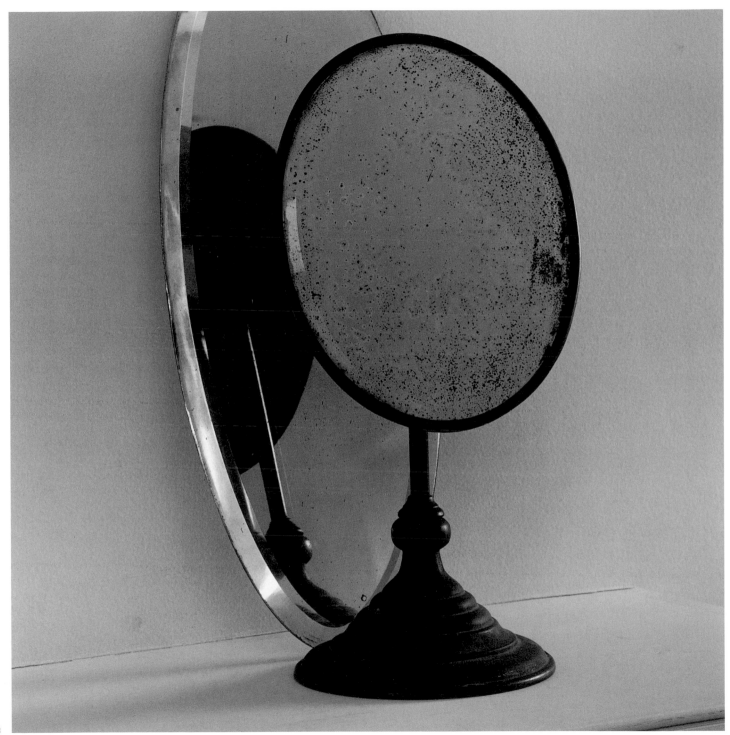

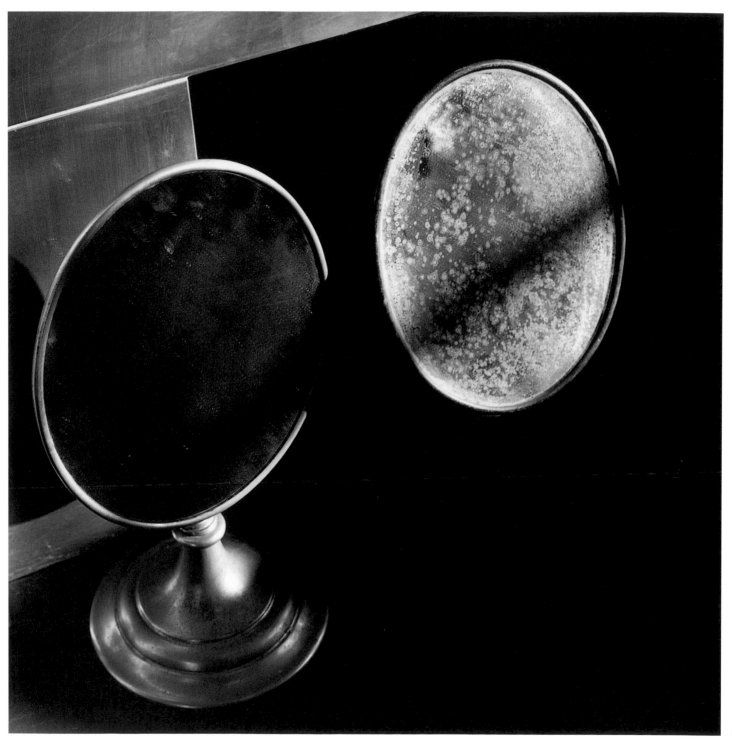

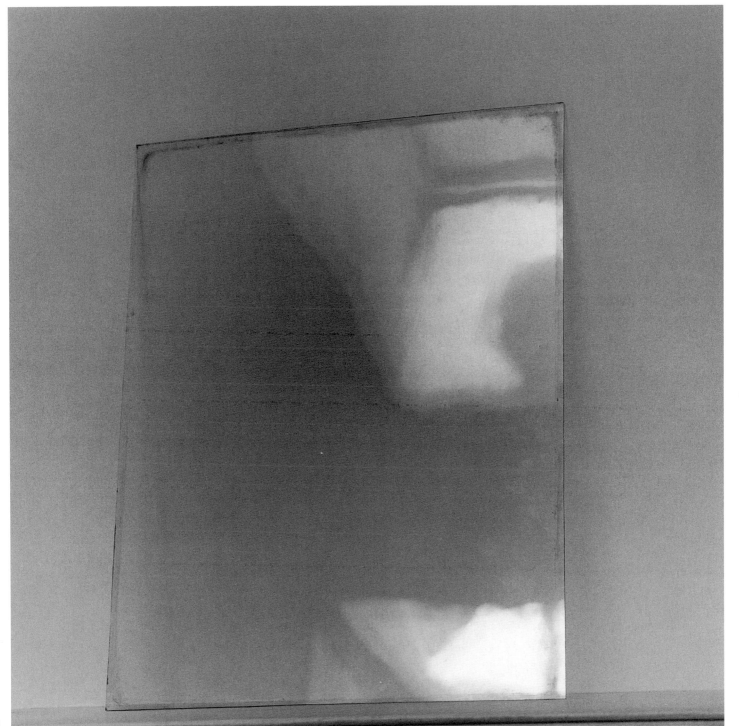

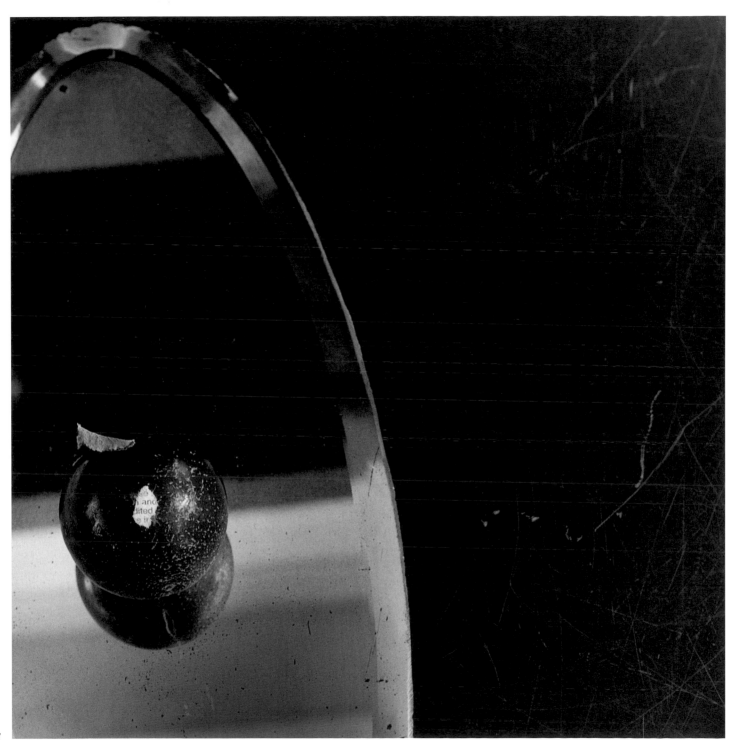

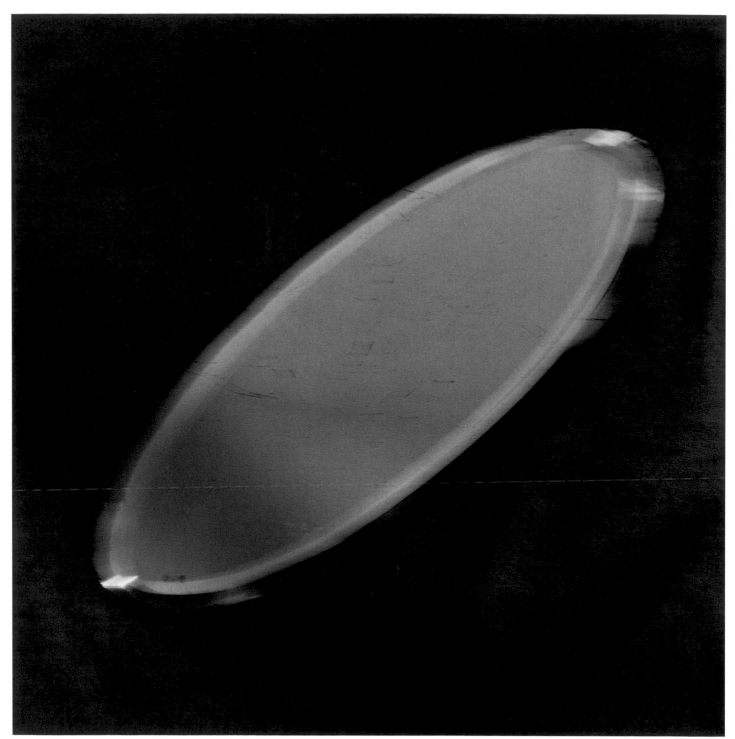

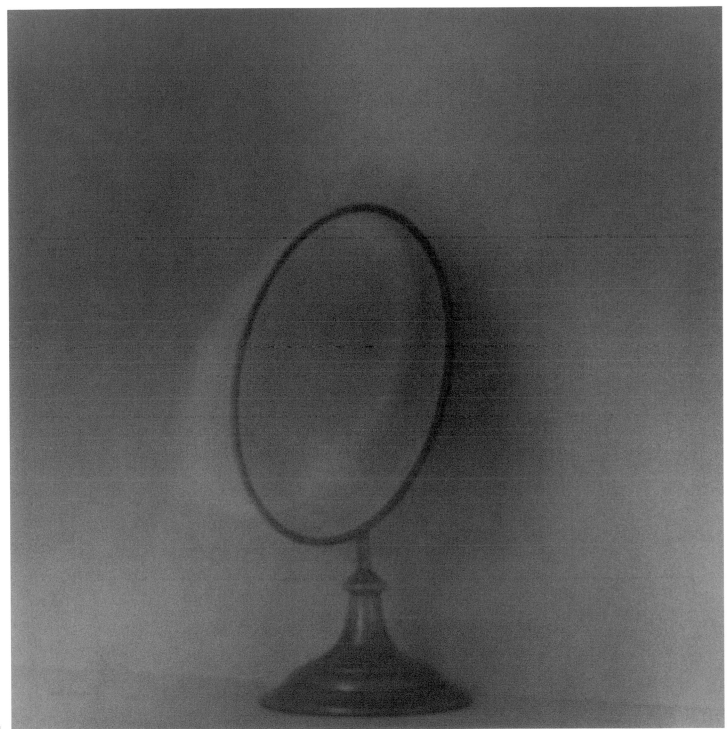

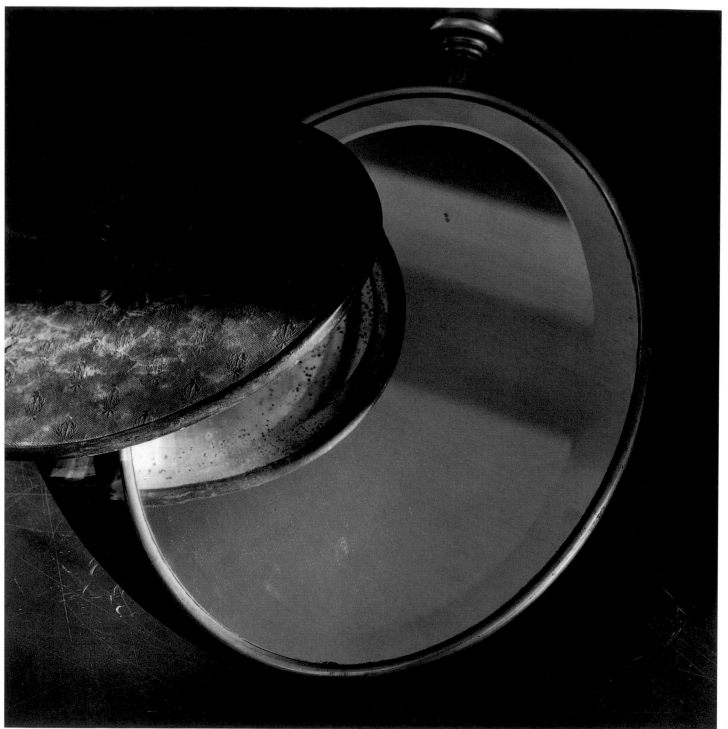

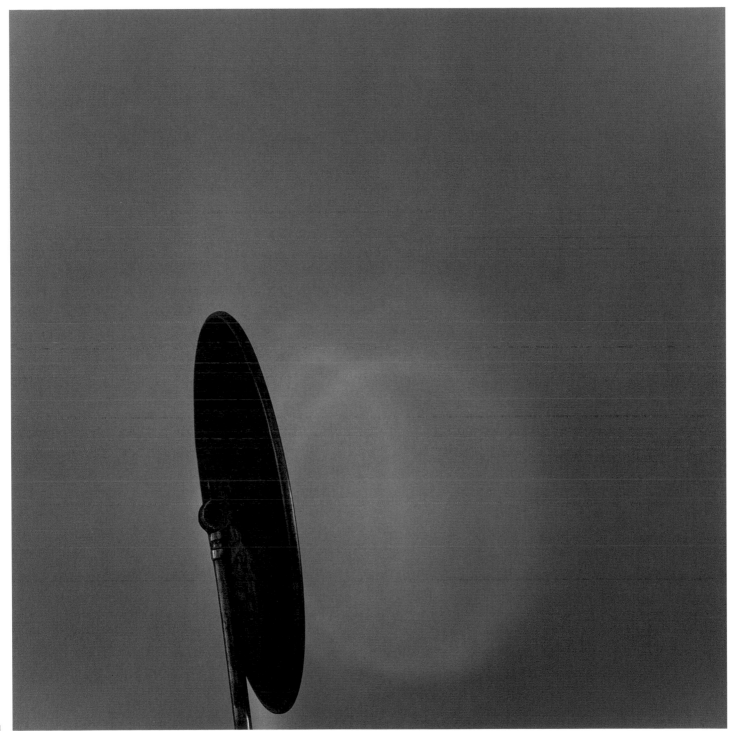

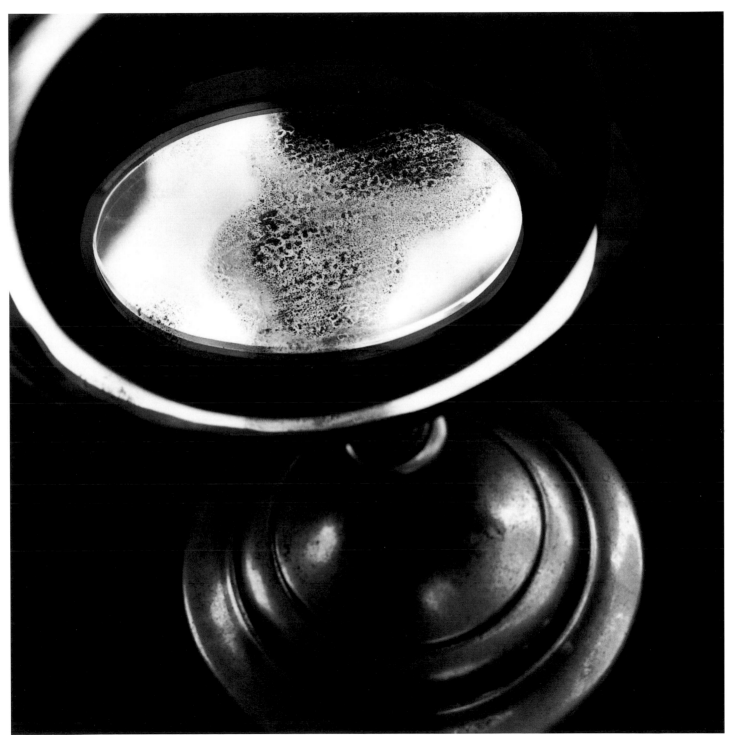

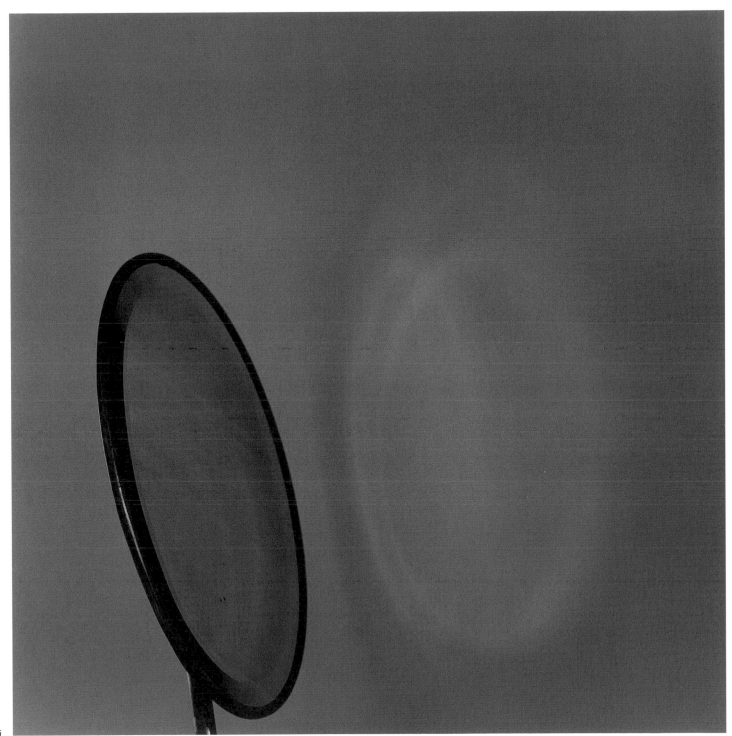

PLATES

MIRRORS

Edmund White

Anything familiar that you look at in a mirror will appear strange, pictorial, on its way to becoming art. Anything, that is, except your own face, since you never see it except in the mirror (or in photos or film). There is so much anxiety when you look at your face (when you *consult* your face, I almost said) perhaps because you read it as you read an augury or the horoscope or your temperature or a letter about yourself you weren't meant to see. This anxiety about personal definition and destiny, this searching for signs (of change, of beauty, of aging, of essential character) is not an element in the way you feel when you glance in a little Indian mirror hung on the wall above the sink and tilted so that you can see the reflection of a spoon. When you see the silver spoon sitting on the slightly stained and irregularly finished porcelain of the sink, you're looking at a familiar utensil from an odd angle, a utensil denied its practical function, deprived of some indefinable aspect of its dimensionality (though a mirror reflection is more dimensional than a photo). The belly of the rounded part of the spoon tapering off into the handle suddenly looks wonderfully esthetic, glowing with its rich warmth against the tarnished eggshell finish and porosity of the enamel.

Both the spoon and the enamel look like things in nature — creatures — and both seem to be expressive. You could imagine looking at them while you were feverish and ascribing personalities to them. The coldness of the metal against the lingering warmth of the sink, sudsy and filled with water a moment ago. The purity and self-containment of the spoon with its perfect symmetry against the blotchy archipelagos of discoloration in the basin. The way the spoon *wants* to curve back on itself in a circular gesture of self-containment, whereas the sink stretches out dully, geographically, like tundra seen from an airplane.

Russian Formalist literary critics in the 1920s spoke of *defamiliarization* as one of the essential strategies of prose. Whereas poetry, they argued, proceeds through taking risks with verbal clarity, the very meaning of words, fiction becomes interesting only when the familiar becomes strange (an evening at the opera described by a Martian). Tolstoy in *War and Peace* gives us the Battle of Borodino as witnessed by a single soldier who has no idea who is winning, where he is, which side is over there — and in the process Tolstoy reinvents war literature and war.

Jeannette Montgomery Barron has done something like that with her mirror photos. She is showing us mirrors, which are already defamiliarizing and estheticizing, as the principle objects in beautiful photographs that are almost mystically strange and pure and certainly fully realized works of art. The mirror, I've said, shows us things that are already on the way to becoming art. These photos take that first inkling of art, the reflection, and place it in compositions that include but also transform and transcend the mirror. We're seeing both the process and the finished procedure, the struggle of the mirror and the accomplished victory of the photograph. Among other things works of art change the original scale, color, dimensionality and material (a Flemish still life shows the glass bowl and pewter pitcher and smoked fish and cut lemon as larger than life with a brighter palette and on a flat canvas covered with oil paints). In Montgomery Barron's work the autumn leaves resting on the mirror are red or yellow or dun-colored, we might imagine, but in the photo they are made up of various tonalities of black and white and they are smaller than real leaves, though we scarcely notice that diminishment due to a human perceptual compensatory tool psychologists call "size constancy." A mirror reflection might fool us for a moment into believing we're looking at the real thing, whereas a *photograph* of a mirror and its reflection is never confused with reality. The process is transformed and polished in the photo and the reflection has become a formal, irrefutably artistic image.

There are many variations here along the axes reflection/real and natural/manmade. In one photograph an arrangement of day lilies are shown out of focus and from an unusual angle in the foreground, whereas the rectangular mirror behind reflects them in their full glory from the best angle and in sharp resolution. But lest we forget that this sharp, splendid version is a "mere" reflection, the glass is beveled at the right and left edges and thereby arbitrarily repeats the nearest petals, a kind of visual "stuttering." Or the round mirror, showing nothing but a uniformly black circular reflection, is posed beside and above a black-hearted sunflower. The natural elements (the flower and the white-veined black marble table top) are irregular, whereas the manmade elements (the striped wallpaper and the mirror) are perfectly regular in their forms.

In another *jeu d'esprit* the round mirror, which is losing its mercury backing, is reflected in a perfectly backed modern silver mirror. The blotched mirror is tilted towards the viewer whereas the silver mirror looks away. Or in another picture dark, stripped branches seemingly float above and below a mirror tilted upwards, though the branches we see reflected in its sur-

face aren't *these* but obviously branches that are still higher and out of our range of vision. In yet another variation on the themes natural/manmade and reflection/real, dead sunflowers lie across the mirror and block out *all* reflection with their shed seeds and wilted carcasses. The mirror is hung at a strange angle and projects off the page but behind it are perfectly uniform unpainted boards — the natural tamed by man, the natural become manmade.

I don't mean to suggest that all these images are just clever ways of staking out every logical possibility along a few axes. For instance, the round mirror seen from the side in a strong light coming from the left projects a soft-edged black shadow on the white wall to the right. The shadow is, of course, a new sort of "reflection" of the familiar round shape, a circle which we see only in the derived shadow, since the mirror itself is turned in such a way that we can't detect its shape directly. This fresh move in a game tightly governed by its rules appeals to the intellect, but the photograph also has a spiritual dimension, as if a lean figure had stepped out on a bare stage at the end of a tragedy or a single glazed teacup were suddenly presented in an utterly spare ceremony. Or we see three black leaves lying on a round mirror; two of the leaves are flat against the mirror and they have no visible reflections but the third leaf is slightly raised and we see its tip doubled. Such an account, however, does nothing to explain how this luminous well of light with the black glossy leaves invading it, all placed against a neutral matte gray wall, becomes something like a magic badge, an imperial insignia, a meditation on status or form without any earthly function.

I suppose Balanchine understood some of the strategies that Montgomery Barron wields so brilliantly. He knew that if he placed a black man and a white woman on an empty stage and dressed them in neutral practice clothes and had them twine and separate, bend and support, lie down and then rise and stand back to back — that then he could count on us to supply the story. The dancers have blank faces and the music is late Stravinsky. The stage is bare. But given these superb bodies of contrasting colors we cannot help making up a drama. In the same way Montgomery Barron knows that if she tilts a mirror in close-up up towards a sky with a few clouds in it and no horizon, we will see it as a hieroglyph of searching. Or if we're given a round mirror in which a bit of paneled door is reflected we'll imagine the door is opening and someone long awaited is about to enter.

Here is a whole coded language for our feelings, a language that like music touches our deepest feelings though no two people would agree precisely on what is being represented. In fact no metaphor is being proposed. We have only a mirror cut in half by a wall or maybe a

door in the foreground, but we see the mirror as sly or shy or at least reticent. Or the extravagantly arcing white fronds of a plant leap with exuberance in front of a mirror that floats in somber air and we see life struggling to assert itself against the dying light. In one photograph the mirror is turned away from us and to the wall and here we feel denied or excluded — and simultaneously for the first time we see the austere form of the mirror on its stand, something worthy of a Prussian dentist of the 1920s. These pictures are "object-portraits" (it's no surprise that Montgomery Barron started out as a portraitist of painters).

A mirror positioned in front of light-struck bushes outside stands on the window sill and looks into the room, away from all the interest, and the reflection of the interior comes out black: null. In one picture the room is so dark that we scarcely see the black mirror at all against the black wall, though we divine it through a faint gray curve along the beveling: we're filled with dread or solemnity or at least high seriousness.

Hokusai, the great Japanese printmaker who came towards the end of three centuries of intense creativity in this medium, chose to show Mount Fuji in print after print — sometimes as an articulated presence drenched in red and excavated by long descending gullies in blue, sometimes as just a detail, a mere downsweep of wings, off in the corner. Sometimes travelers are shown wading through a torrential river in the foreground while Fuji rises tranquilly in the distance. Or peasants at the end of the day lead oxen home loaded down with bundles of reeds while a snow-covered Fuji rises serenely through banks of mist. Or Fuji is just a blip behind towers of cut wood stacked in a timber-yard. In one picture I can't find, possibly by Hokusai, I seem to recall that a monk sitting in his hermitage has been studying Fuji's reflection in a round mirror, but now he is so moved by the image that he has flung his head back in ecstasy and is looking directly at the mountain (though upside down). This image, the one I can't locate and that exists for me now only in my faulty memory, is the one I most associate with Jeannette Montgomery Barron's extraordinary enterprise — spiritual and repetitious, though varying in every image in some small crucial way, haunted by a Buddhist concept of purity, something at once domestic (the mirror on the sill, the monk's little hut) and transcendent.

SPIEGEL

Edmund White

Alles Bekannte, das man im Spiegel anschaut und auf dem Weg ist, Kunst zu werden, erscheint fremd, bildhaft. Alles, was ist, außer dem eigenen Gesicht, weil man es nur im Spiegel (oder auf Fotos oder in Filmen) sehen kann. Es liegt so viel Besorgnis darin, wenn man das eigene Gesicht betrachtet (wenn man es *befragt*, hätte ich fast gesagt), vielleicht weil man es wie ein Omen oder ein Horoskop liest, wie seine Temperatur auf dem Fieberthermometer oder einen Brief über sich selbst, den man eigentlich nicht sehen sollte. Diese Ängste um die Definition der eigenen Person und ihre Bestimmung, diese Suche nach Zeichen (von Veränderung, Schönheit, Altern, eigentlichem Charakter) fehlen in dem Gefühl, das entsteht, wenn man flüchtig in den kleinen indischen Spiegel schaut, der leicht schräg an der Wand über dem Spülbecken hängt und einen Löffel spiegelt. Wenn man den silbernen Löffel auf der leicht fleckigen, unregelmäßigen Glasur des Porzellanbeckens liegen sieht, schaut man sich einen vertrauten Gegenstand aus einem ungewohnten Winkel an, einen Gegenstand, der seine praktische Funktion verloren hat, eines undefinierbaren Teils seiner Dimensionalität beraubt ist (obwohl eine Spiegelung dimensionaler ist als ein Foto). Der Bauch des Löffels, der sich zum Stiel verengt, sieht plötzlich wundervoll ästhetisch aus, glüht in reicher Wärme vor der matten eierschalfarbenen Glasur und der Porosität des Emailles.

Der Löffel und das Emaille wirken wie etwas Natürliches – Kreaturen – und scheinen etwas auszudrücken. Man kann sich vorstellen, dass man sie in fiebrigem Zustand ansieht und ihnen eine Persönlichkeit zuschreibt. Die Kälte des Metalls gegen das noch warme Becken, das kurz zuvor noch voller Schaum und Wasser war. Die Reinheit und Selbstbeschränkung des Löffels mit seiner vollkommenen Symmetrie gegen die fleckigen und entfärbten Archipele im Bassin. Wie sich der Löffel in einer zirkulären Geste der Selbstbeschränkung wieder in sich zurück biegen *möchte*, während sich das Spülbecken gleichgültig ausstreckt, geografisch, wie eine Tundra, die man aus dem Flugzeug sieht.

Russische Literaturkritiker des Formalismus sprachen in den zwanziger Jahren von *Entfremdung* als einer wesentlichen Strategie von Prosa. Poesie, behaupteten sie, gehe das Wagnis wörtlicher Klarheit, wortwörtlicher Bedeutung ein. Fiktion aber werde nur interessant, wenn das Vertraute fremd wird (ein Opernabend, von einem Marsmenschen beschrieben). Tolstoi

schildert uns in *Krieg und Frieden* die Schlacht von Borodino aus der Sicht eines einzelnen Soldaten, der keine Ahnung davon hat, wer gewinnt, wo er sich befindet und wer auf der anderen Seite kämpft – und erfindet in diesem Prozess die Kriegsliteratur und den Krieg neu.

Jeannette Montgomery Barron hat etwas Ähnliches mit ihren Spiegelfotografien getan. Sie zeigt uns Spiegel, die entfremden und ästhetisieren, als elementare Objekte schöner Fotografien – auf fast mystische Art und Weise fremd und rein und ganz und gar als Kunstwerke realisiert. Der Spiegel, wie ich schon sagte, zeigt uns Dinge, die bereits auf dem Weg sind, Kunst zu werden. Die Fotos fangen diese erste Ahnung von Kunst ein, die Spiegelung, und stellen sie in Kompositionen, die den Spiegel einschließen, aber auch transformieren und transzendieren. Wir sehen den Prozess wie auch das Ende des Verfahrens, den Kampf des Spiegels und den erreichten Sieg der Fotografie. Kunstwerke verändern unter anderem ursprüngliche Maßstäbe, Farben, Dimensionen und Materialität (ein flämisches Stillleben zeigt die Glasschale, den Zinnkrug, den geräucherten Fisch und die geschnittene Zitrone übergroß in hellerer Farbskala und auf von Ölfarbe bedeckter, flacher Leinwand). Bei Montgomery Barrons Bildern mögen wir uns die Herbstblätter auf dem Spiegel rot, gelb oder gräulich braun vorstellen, auf dem Foto aber haben sie verschiedene Tonwerte zwischen Schwarz und Weiß und sind kleiner als echte Blätter, auch wenn wir dies wegen des menschlichen Wahrnehmungsausgleichs, den die Psychologen „Größenkonstante" nennen, kaum bemerken. Die Reflexion eines Spiegels täuscht uns vielleicht einen Augenblick lang vor, wir schauten auf das reale Objekt, die *Fotografie* eines Spiegels und dessen Reflexion hingegen vermischt sich niemals mit der Realität. Der Prozess ist im Foto transformiert und verfeinert und die Reflexion ist zu einem formalen, unabweisbar künstlerischen Bild geworden.

Entlang der Achsen Reflexion/Reales und Natürlich/Künstlich gibt es hier viele Variationen. Auf einem Foto ist unscharf im Vordergrund ein aus ungewöhnlichem Winkel aufgenommenes Liliengesteck zu sehen, während der rechteckige Spiegel dahinter die volle Schönheit des Gestecks gestochen scharf und aus bestem Aufnahmewinkel zurückwirft. Aber damit wir nicht vergessen, dass diese scharfe, großartige Version eine „bloße" Reflexion ist, hat das Glas an seinem rechten und linken Rand abgeschrägte Kanten und wiederholt willkürlich die nächstgelegenen Blütenblätter – eine Art visuelles „Stottern". Oder ein runder Spiegel zeigt nichts außer einer gleichmäßig schwarzen zirkularen Reflexion, und daneben beziehungsweise oberhalb ist eine Sonnenblume mit schwarzer Innenfläche positioniert. Die natürlichen

Elemente (die Blume und die weiß geäderte, schwarze Marmortischplatte) haben unregelmäßige Formen, die künstlichen Elemente (die gestreifte Tapete und der Spiegel) sind vollkommen regelmäßig.

In einem anderen *jeu d'esprit* spiegelt sich ein runder Spiegel, der seine Quecksilberauflage verliert, in einem makellosen modernen Silberspiegel. Der fleckige Spiegel neigt sich dem Betrachter zu, der Silberspiegel schaut weg. Wieder in einem anderen scheinen nackte Äste über und unter einem nach oben gekippten Spiegel zu treiben, obwohl die Äste, die wir gespiegelt sehen, offenbar andere sind und noch höher, außerhalb unseres Blickfelds liegen. In einer weiteren Variation der Themen Natürlich/Künstlich und Reflexion/Reales liegen tote Sonnenblumen quer über dem Spiegel und verdecken mit ihren ausgefallenen Kernen und verwelkten Überresten *alle* Reflexion. Der Spiegel hängt in einem merkwürdigen Winkel und ragt über die Seite hinaus, aber dahinter sind vollkommen gleichförmige, unbemalte Bretter – das Natürliche ist vom Menschen gebändigt, es wird künstlich.

Ich will damit nicht sagen, dass all diese Bilder lediglich ein cleverer Weg wären, jede logische Möglichkeit entlang einiger weniger Achsen abzustecken. Der runde Spiegel zum Beispiel, der in einem starkem Licht von links von der Seite zu sehen ist, wirft einen weich randigen schwarzen Schatten auf die weiße Wand rechts. Der Schatten ist natürlich eine neue Art von „Reflexion" der vertrauten runden Form, ein Kreis, den wir nur in dem geworfenen Schatten sehen, da der Spiegel selbst so gedreht ist, dass wir seine Form nicht direkt erkennen können. Diese frische Bewegung in einem Spiel, das fest von seinen Regeln beherrscht wird, spricht den Intellekt an. Aber die Fotografie hat auch eine spirituelle Dimension, als ob eine hagere Gestalt am Ende einer Tragödie auf eine leere Bühne getreten oder eine glänzende Teetasse plötzlich in einer völlig überflüssigen Zeremonie präsentiert worden wäre. Oder wir sehen drei schwarze Blätter auf einem runden Spiegel liegen; zwei der Blätter liegen flach auf dem Spiegel ohne sichtbare Spiegelung, das dritte aber ist leicht erhöht und wir sehen seine Spitze doppelt. Die Beschreibung erklärt allerdings noch nicht, wie diese strahlende Lichtquelle zusammen mit den schwarz glänzenden Blättern, die in sie eindringen – vor dem Hintergrund einer neutralen mattgrauen Wand – zu einer Art von magischem Abzeichen wird, einem königlichen Ehrenzeichen, einer Meditation über Status und Form ohne jegliche irdische Funktion.

Es ist davon auszugehen, dass Balanchine die Strategien kannte, die Montgomery Barron so brillant verfolgt. Er wusste: Wenn er einen schwarzen Mann und eine weiße Frau auf eine leere

Bühne stellt, sie in neutrale Trainingskleidung steckt und sie sich dann ineinander verschlingen und voneinander trennen lässt, sich biegen und stützen, hinlegen und aufstehen und dann Rücken an Rücken stehen lässt – dann kann er sich darauf verlassen, dass wir die Geschichte ergänzen. Die Tänzer haben glatte Gesichter und die Musik ist ein später Strawinsky. Die Bühne ist leer. Aber angesichts dieser großartigen Körper in kontrastierenden Farben können wir gar nicht anders, als daraus ein Drama zu machen. Auf dieselbe Weise weiß Montgomery Barron: Wenn sie einen Spiegel in Nahaufnahme gegen einen Himmel kippt, an dem es ein paar Wolken gibt, aber keinen Horizont – dann verstehen wir dies als Hieroglyphe für Suchen. Oder wenn man uns einen runden Spiegel zeigt, in dem sich ein Teil einer getäfelten Tür reflektiert, stellen wir uns vor, dass sich die Tür öffnet und jemand lang Erwartetes tritt ein.

Es ist eine umfassende, verschlüsselte Sprache für unsere Gefühle, eine Sprache, die wie die Musik unsere tiefsten Gefühle berührt, obwohl es keine zwei Menschen gibt, die präzise darin übereinstimmen würden, was gezeigt wird. Tatsächlich wird keine Metapher angeboten. Wir haben nur einen Spiegel, der von einer Wand oder vielleicht einer Tür im Vordergrund halbiert wird, aber wir empfinden ihn als still, scheu oder zumindest zurückhaltend. Oder die weißen, extravagant gebogenen Wedel einer Pflanze springen vor einem Spiegel, der in trüber Luft schwebt, üppig empor, und wir stellen uns vor, wie das Leben darum kämpft, sich gegen das sterbende Licht zu behaupten. In einem Foto ist der Spiegel von uns weggedreht, der Wand zu, und wir fühlen uns abgelehnt oder ausgeschlossen. Gleichzeitig bemerken wir zum ersten Mal die strenge Form des Spiegels auf seinem Ständer – eines preußischen Zahnarztes in den zwanziger Jahren des vergangenen Jahrhunderts würdig. Diese Bilder sind „Objekt-Porträts" (es überrascht nicht, dass Montgomery Barron als Porträtfotografin von Malern angefangen hat).

Ein Spiegel steht auf einem Fensterbrett, draußen sind vom Licht gestreifte Büsche, sein Blick aber geht in den Raum, abgewandt von allem Interessanten, und die Reflexion des Interieurs ist schwarz: Null. Auf einem Bild ist der Raum so dunkel, dass wir den schwarzen Spiegel vor der schwarzen Wand kaum erkennen können, wir erahnen ihn nur anhand einer schwachen grauen Kurve entlang seiner Kante: Uns erfüllt ein Gefühl der Erhabenheit, Feierlichkeit oder zumindest größter Ernsthaftigkeit.

Hokusai, der große japanische Holzschnittmacher, der am Ende dreier für dieses Medium hoch kreativer Jahrhunderte stand, hat sich dafür entscheiden, Druck für Druck den Fujiyama

zu zeigen – manchmal als deutlich hervortretende Erscheinung, getränkt in Rot mit tiefen, lang abfallenden Rinnen in Blau, manchmal nur als Detail, hinten in der Ecke, eine bloße Horizontlinie aus Flügeln. Manchmal sind Reisende gezeigt, wie sie im Vordergrund durch einen reißenden Fluss waten und der Fujiyama sich ruhig in der Ferne erhebt. Oder Landarbeiter führen am Ende eines Tages mit Schilfrohr beladene Ochsen nach Hause, während sich ein Schnee bedeckter Fujiyama friedlich über Nebelschwaden erhebt. Oder der Fujiyama ist nur ein Echo hinter Türmen aus geschnittenem Holz, gestapelt in einem Holzverschlag. In einem Bild, das ich nicht finden kann, das aber wahrscheinlich von Hokusai ist, glaube ich mich zu erinnern, dass ein Mönch in seiner Klause sitzt und die Reflexion des Fujiyama in einem runden Spiegel studiert. Jetzt aber bewegt ihn das Bild so sehr, dass er seinen Kopf verzückt zurückwirft und den Berg direkt anschaut (wenn auch auf dem Kopf stehend). Dieses Bild, das ich nicht finden kann und das nurmehr in meiner lückenhaften Erinnerung existiert, ist das, was ich am stärksten mit Jeannette Montgomery Barrons außergewöhnlichem Vorhaben assoziiere – spirituell und sich wiederholend, wenngleich bei jedem Bild in einem kleinen, entscheidenden Detail variiert, heimgesucht von einem buddhistischen Konzept von Reinheit, gleichzeitig heimisch (der Spiegel auf dem Fensterbrett, die kleine Hütte des Mönchs) und transzendent.

(übersetzt von Miriam Wiesel)

THANKS to my husband, James, who believed in this series
from the start. My children, Isabelle and Ben, are a constant
inspiration. Thanks to Hans Werner Holzwarth for his vision and
beautiful design. Leslie Yudelson Valiunas printed all of the
photographs for this book. Once again, I thank her.

The photographs in this book were printed in an edition of 10 on 20 x 24 inch
paper, with the exception of *Mirrors #1–4* and *Mirror #8,* which were printed in
an edition of 25 on 16 x 20 and 20 x 24 inch paper.

Jeannette Montgomery Barron — Mirrors Spiegel
Design: Hans Werner Holzwarth
Editing / Lektorat: Angelika Stricker
Lithography / Lithografie: Gert Schwab Scantechnik, Göttingen
Printing / Druck: Jütte-Messedruck, Leipzig
Copyright 2004 for the photographs / für die Fotografien: Jeannette Montgomery Barron;
for the text / für den Text: Edmund White; for this edition / für diese Ausgabe:
Holzwarth Publications GmbH, Bismarckstrasse 8e, D-14109 Berlin,
www.holzwarth-publications.com
All rights reserved
First edition / Erste Ausgabe 2004
ISBN 3-935567-15-4
Printed in Germany